*A*

*Costume Journal*

*With the*

*Watercolors of Jean Masetti*

*This book is dedicated
to my daughter, Maggie,
and her costuming friends.*

All Art Works © Jean Masetti 2015 All rights reserved. This book may not be reproduced in whole or part in any form without written permission of the author.

Additional copies of this book may be ordered from
http://tinyurl.com/nph74ld

A couple of years ago, I went to a Pumpkin Regency Tea with my daughter, given by her friend and her mother. There were beautiful decorations, wonderful food, and the guests were all dressed in period costume. All these were reflective of an era that took us back to another time and place.

This tea inspired me to start a journal of painted watercolor sketches of my daughter and her friends dressed in costume. I then reproduced these sketches in a book.

I have continued to paint these little watercolor sketches in my little Journal and recently have been encouraged to re-print my book, with my newest work, for the enjoyment of the reader.

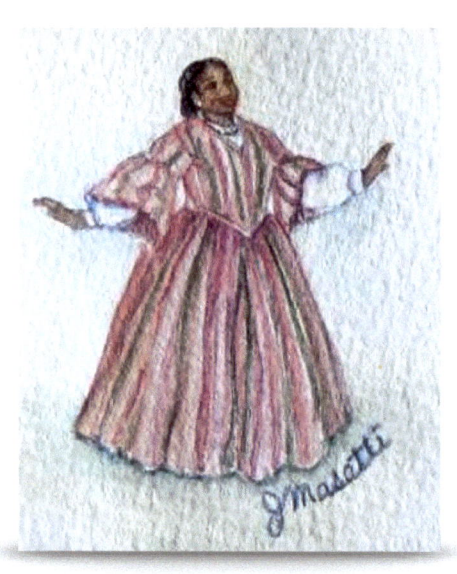

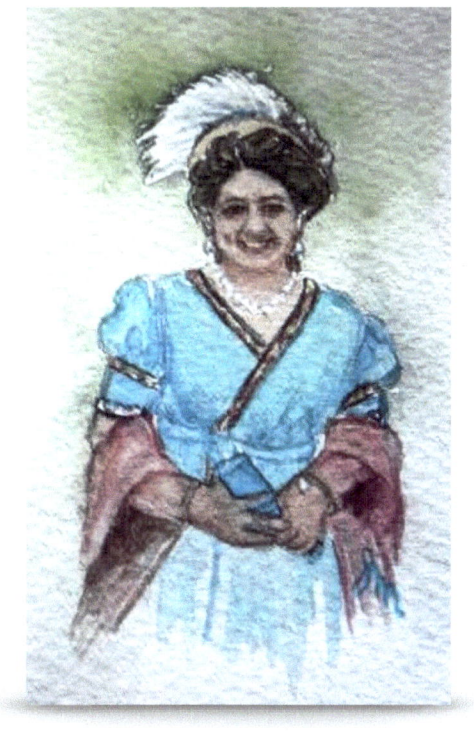

*I began this book with a collection of watercolors that feature the Regency period in time.*

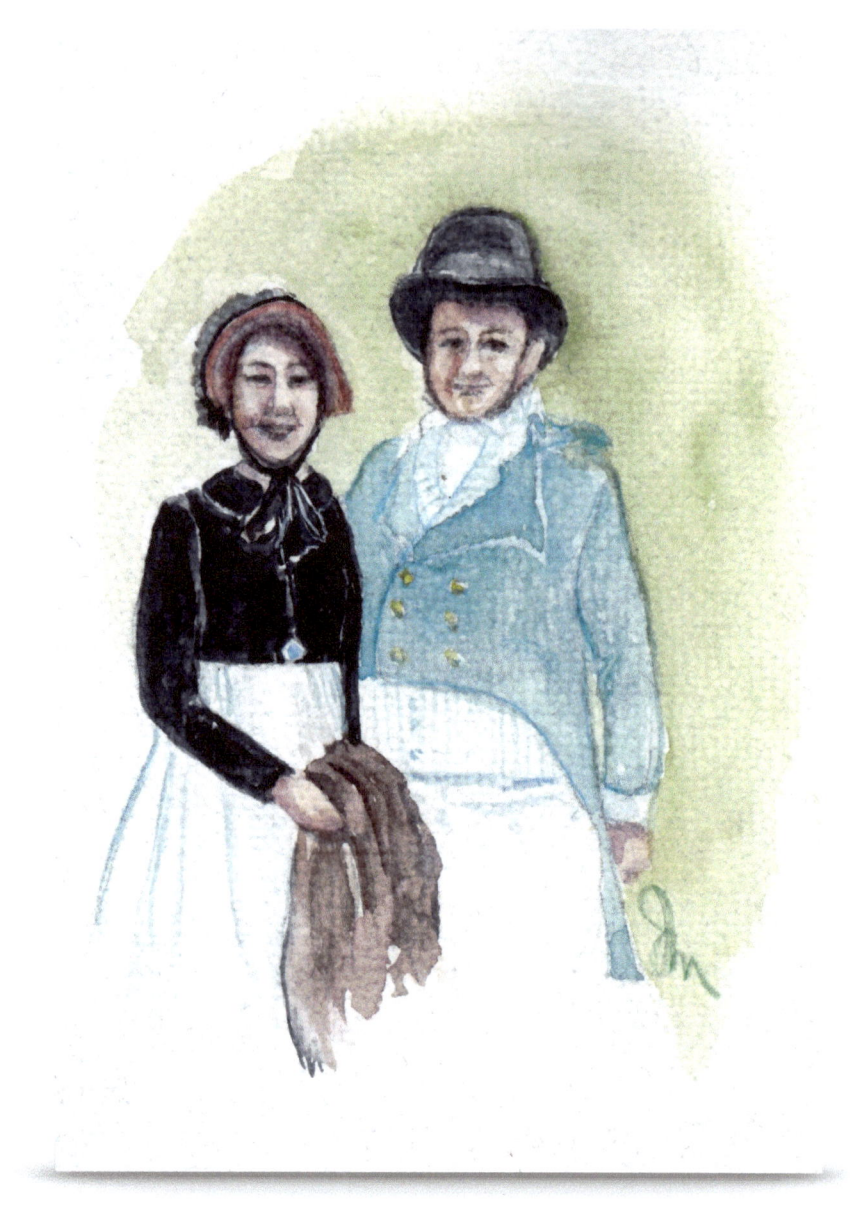

*Out for a Walk Through the Garden*

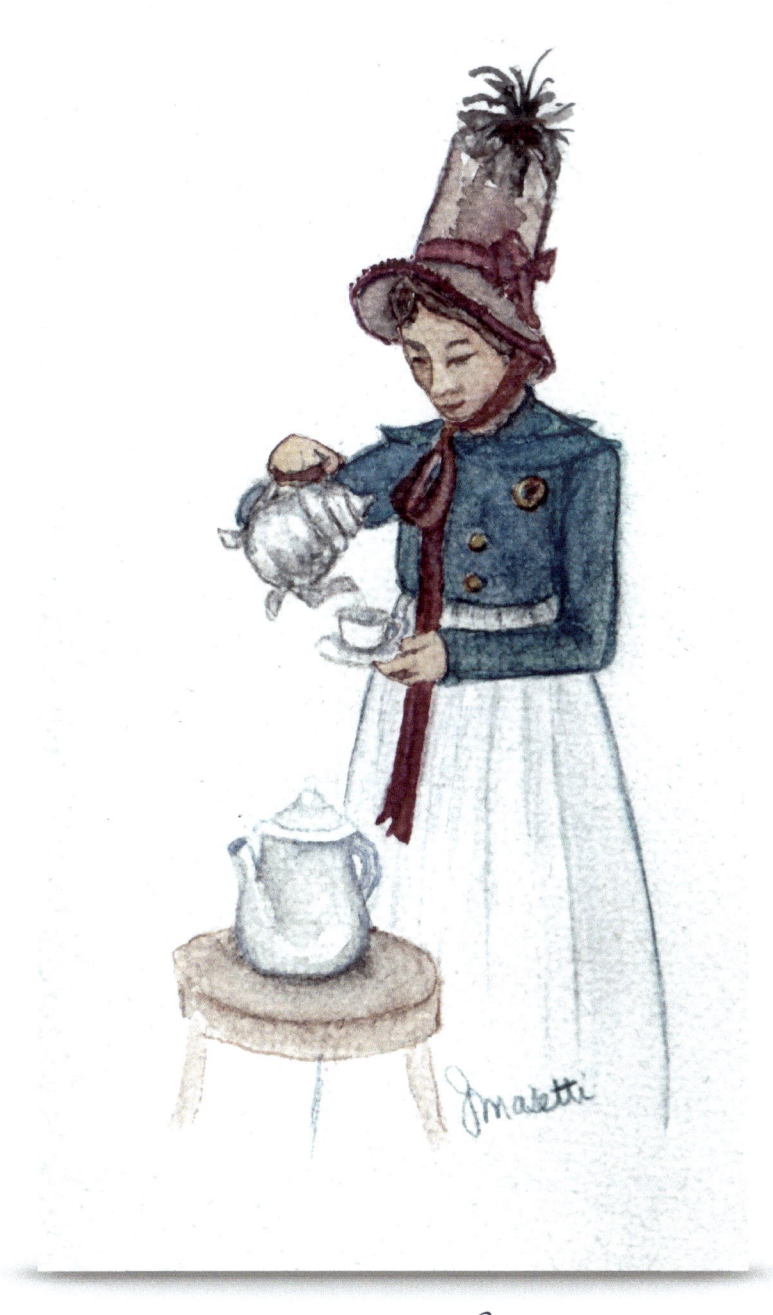

*Regency Pumpkin Tea*

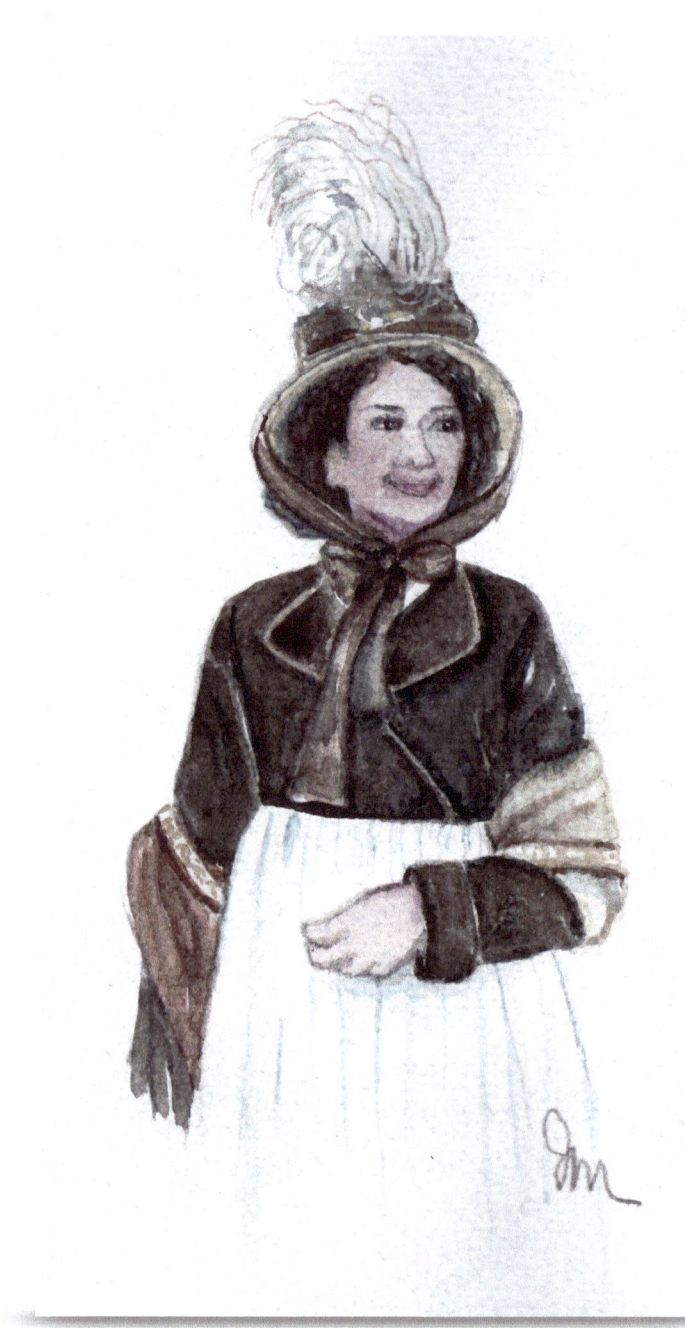

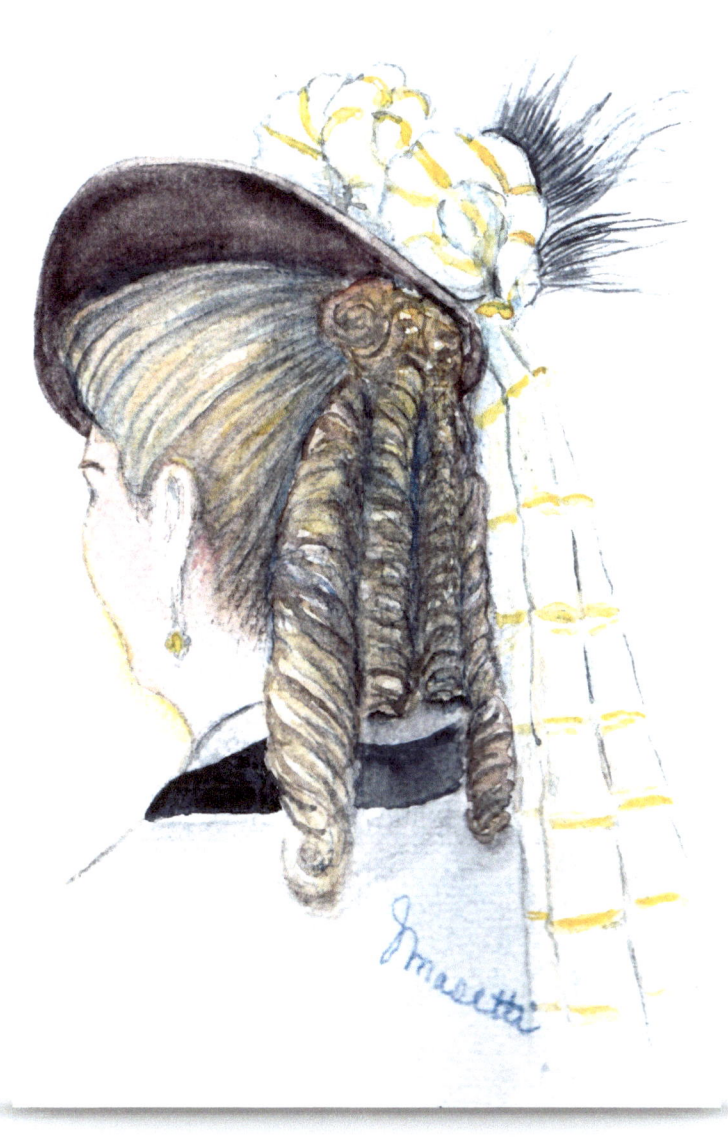

Say Hello to Friends

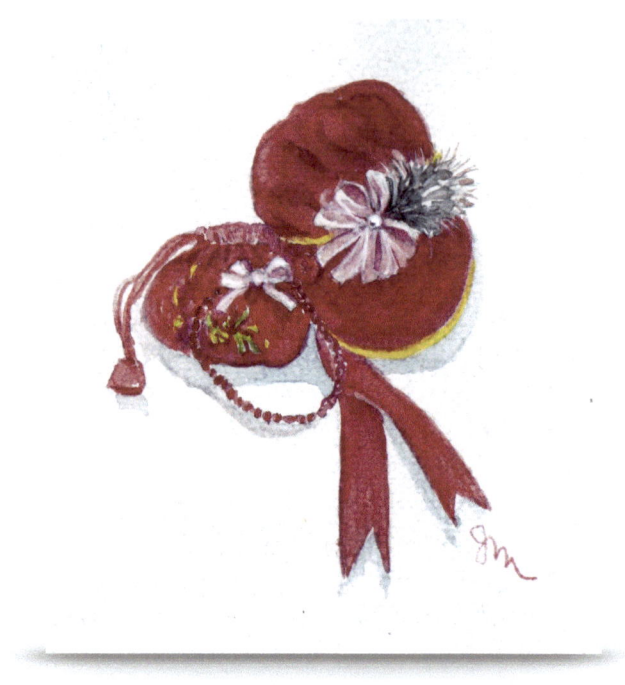

*Bonnet and Reticule*

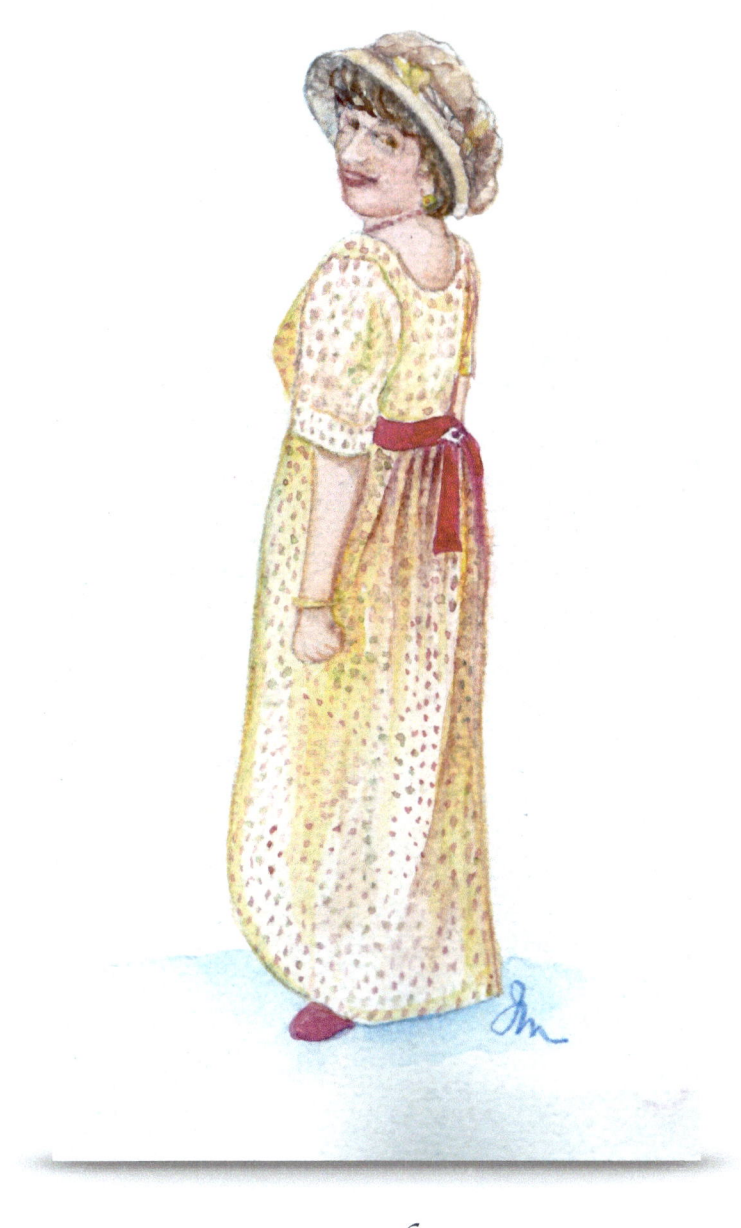

*I'm Ready to Go*

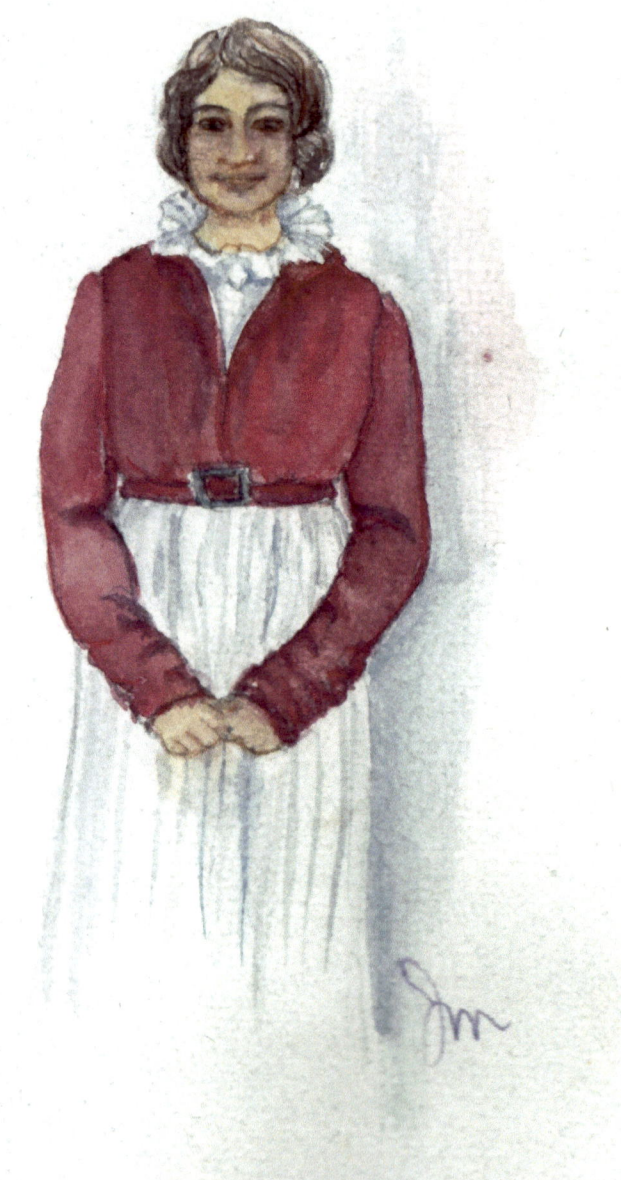

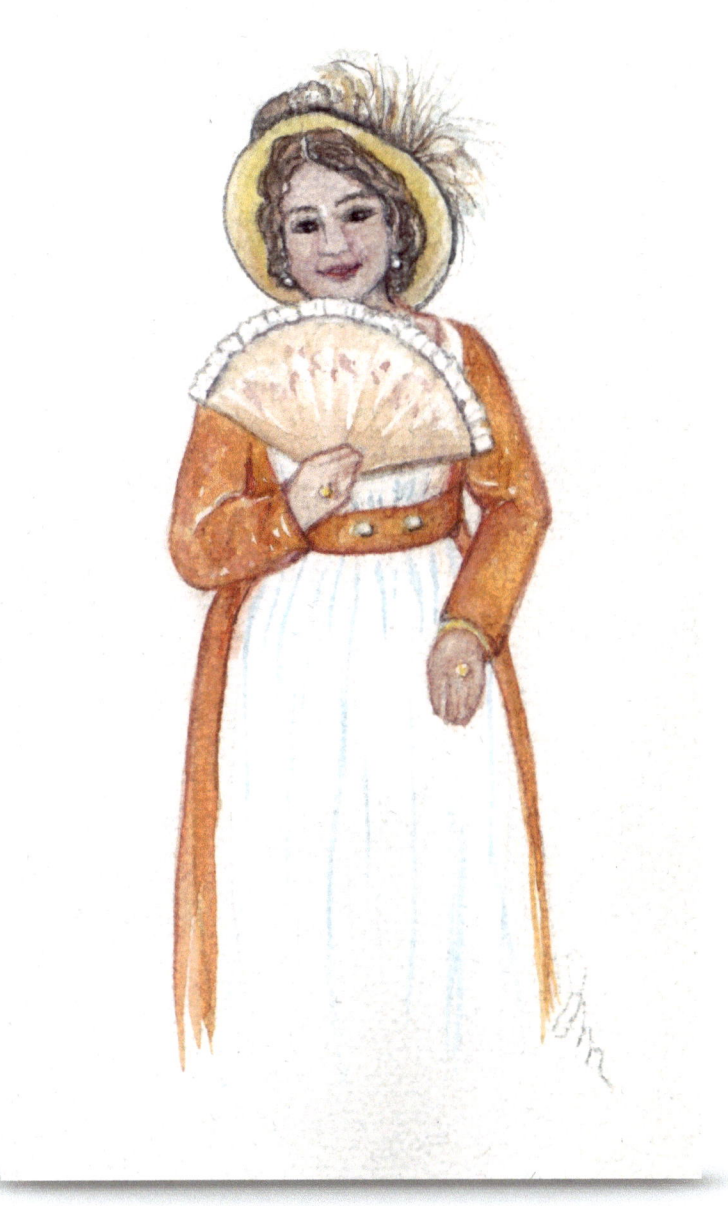

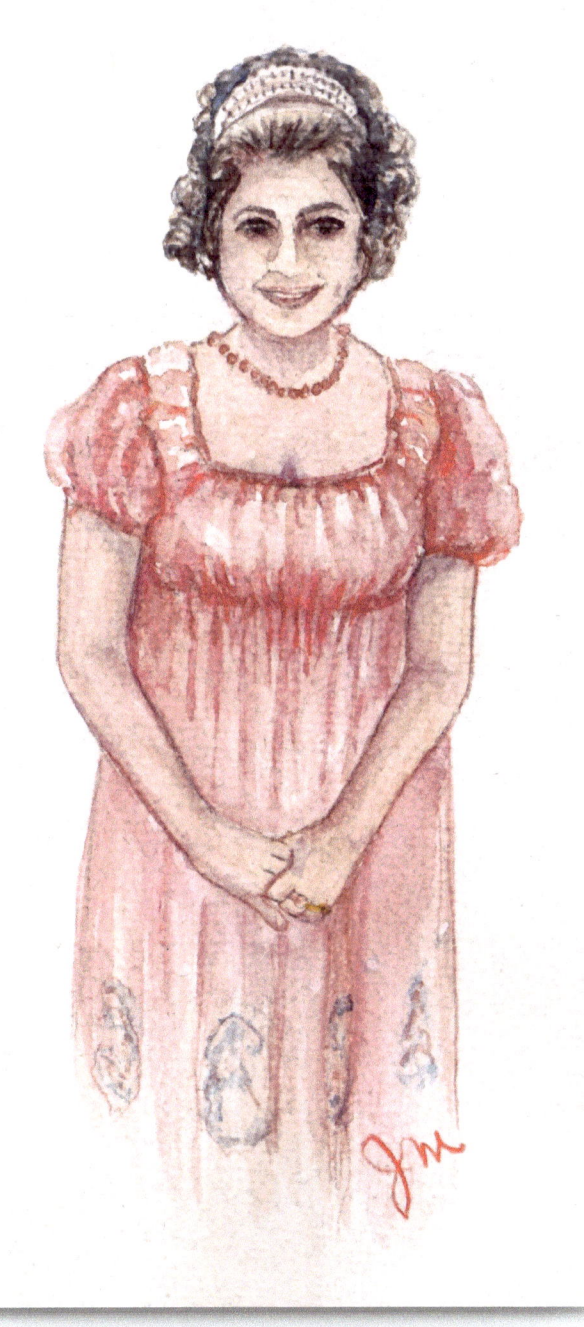

*Dinner Is Served*

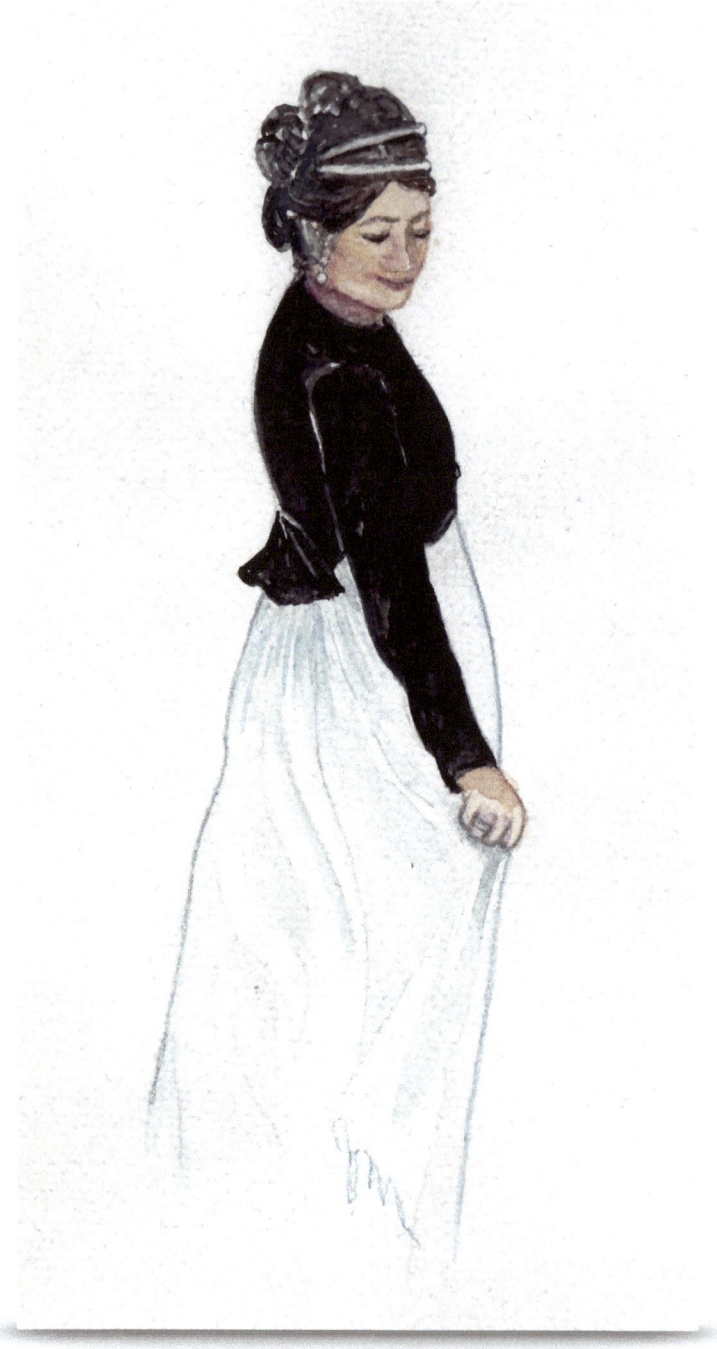

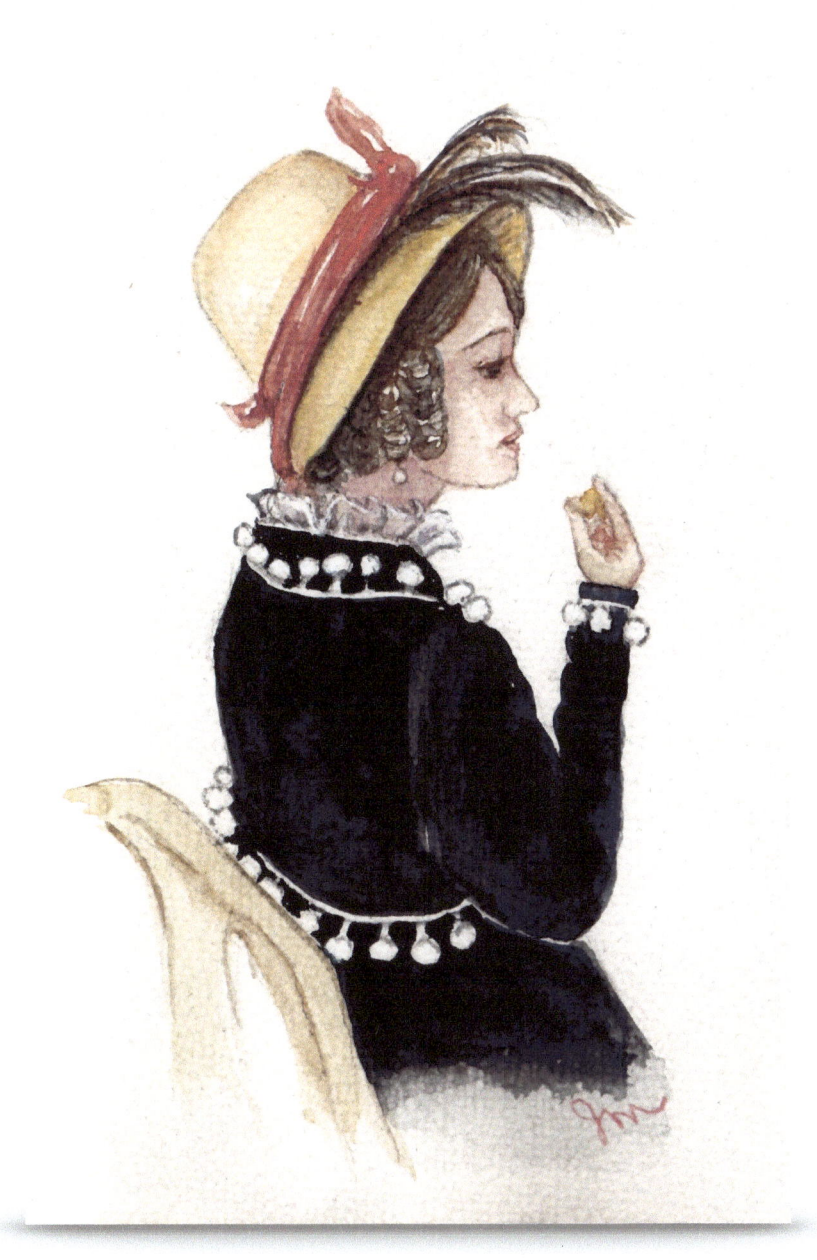

*The tea cakes are delicious!*

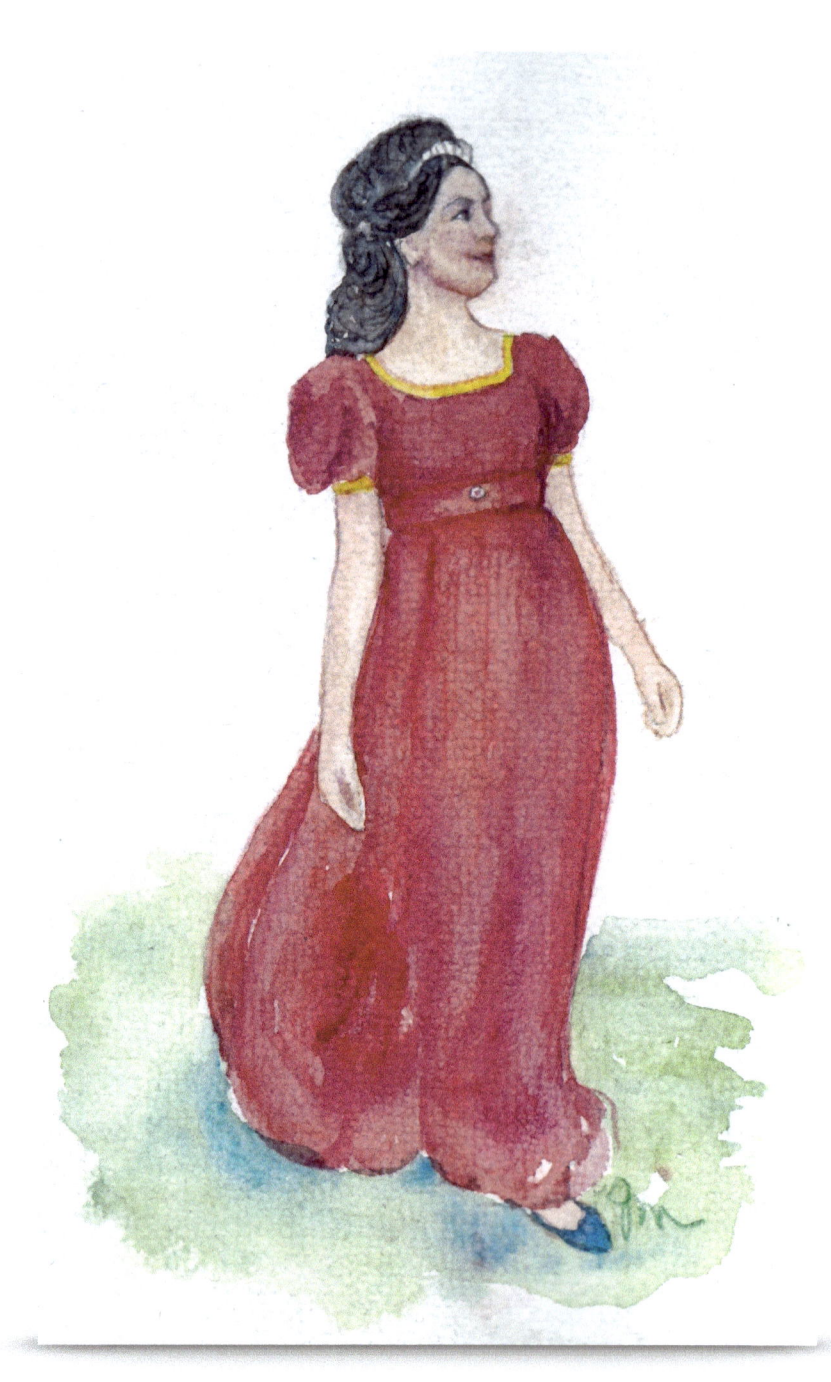

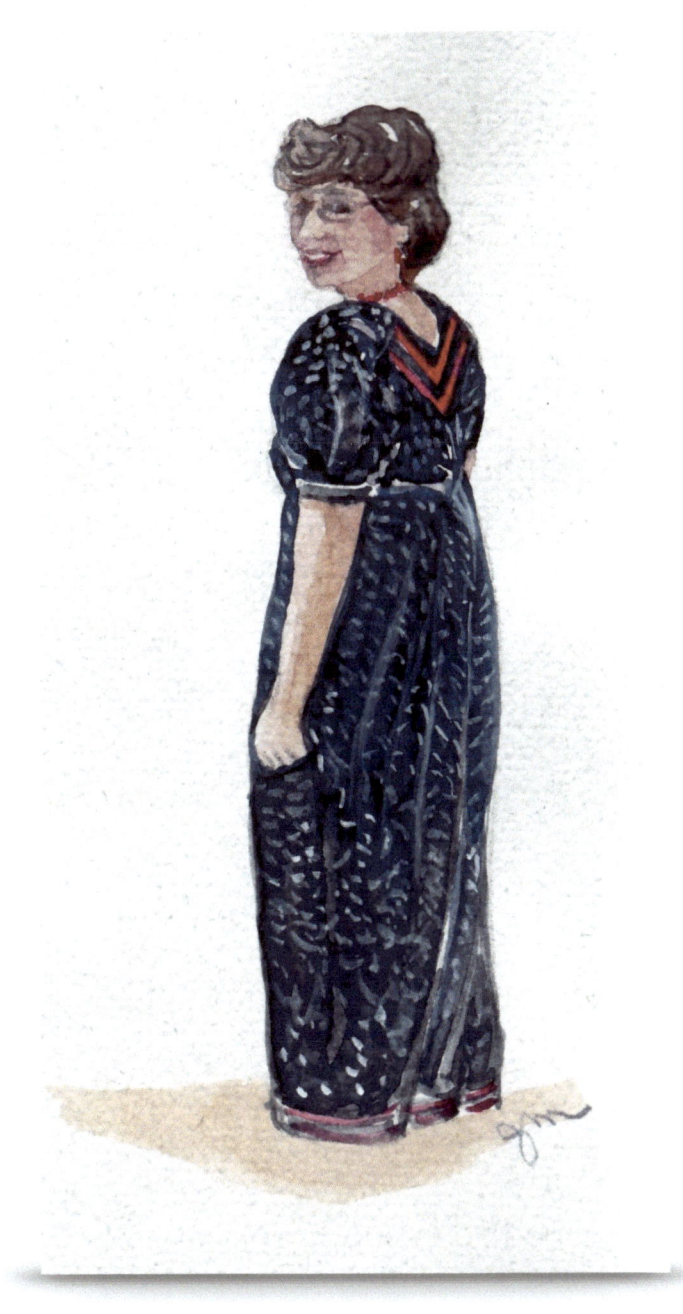

*A surprise! A new Regency dress, made by my daughter.*

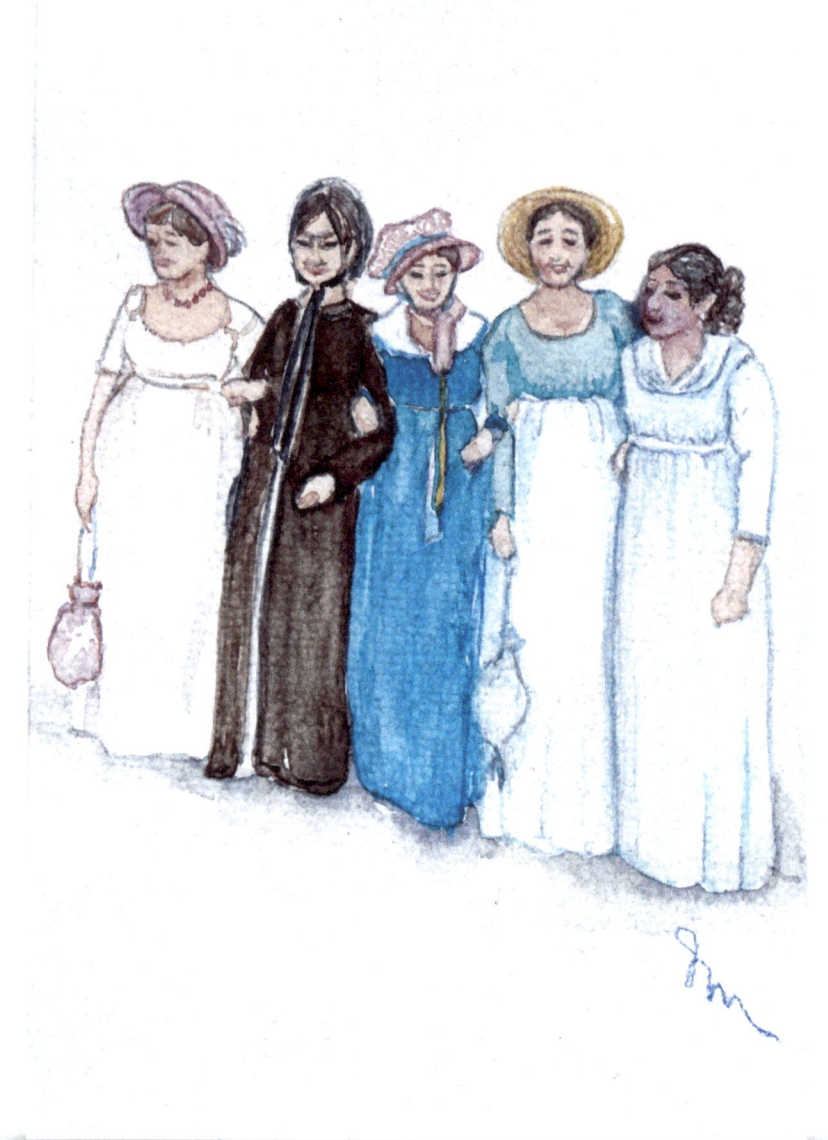

*The Bennet sisters: Jane, Elizabeth, Mary, Kitty and Lydia.*

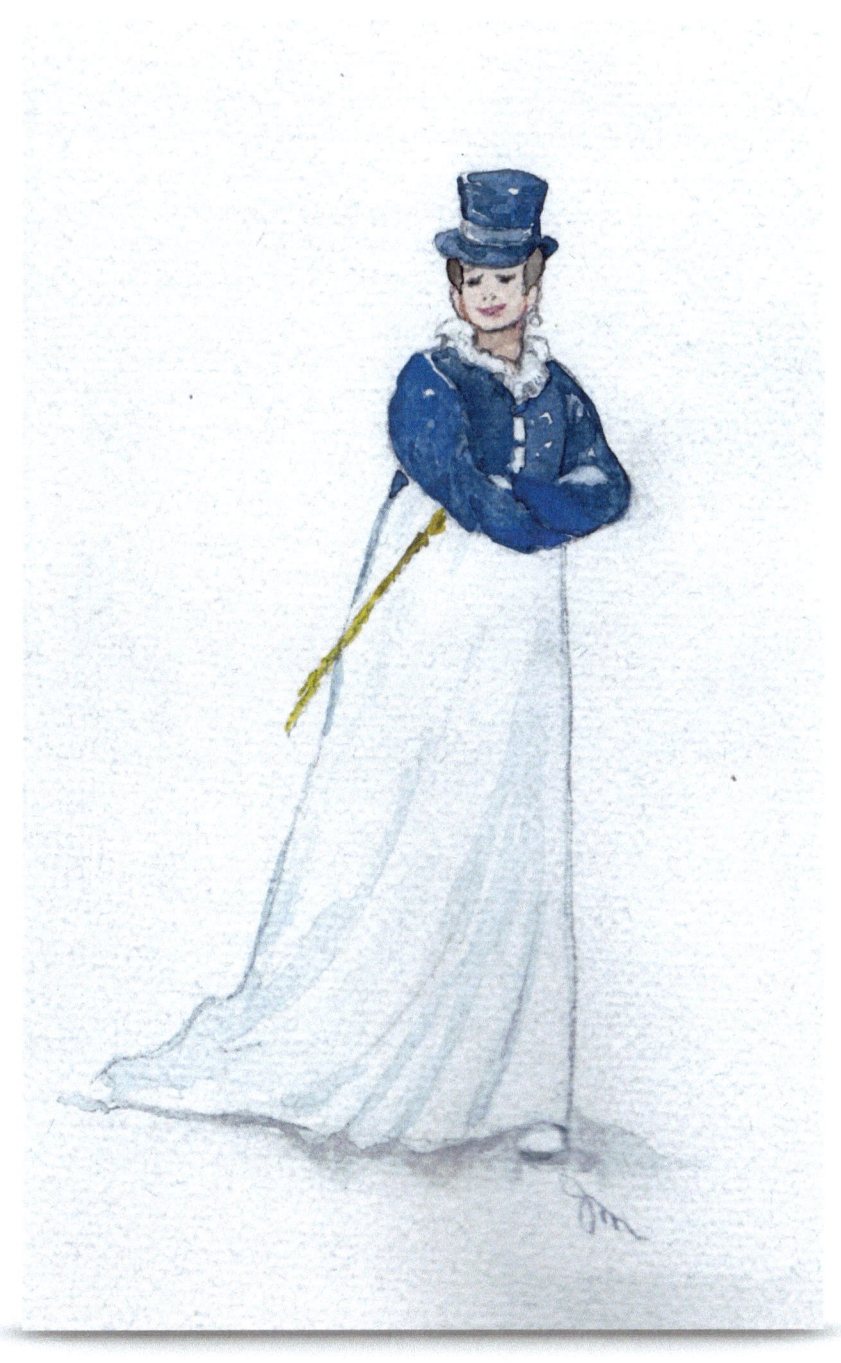

*Miss Bingley*

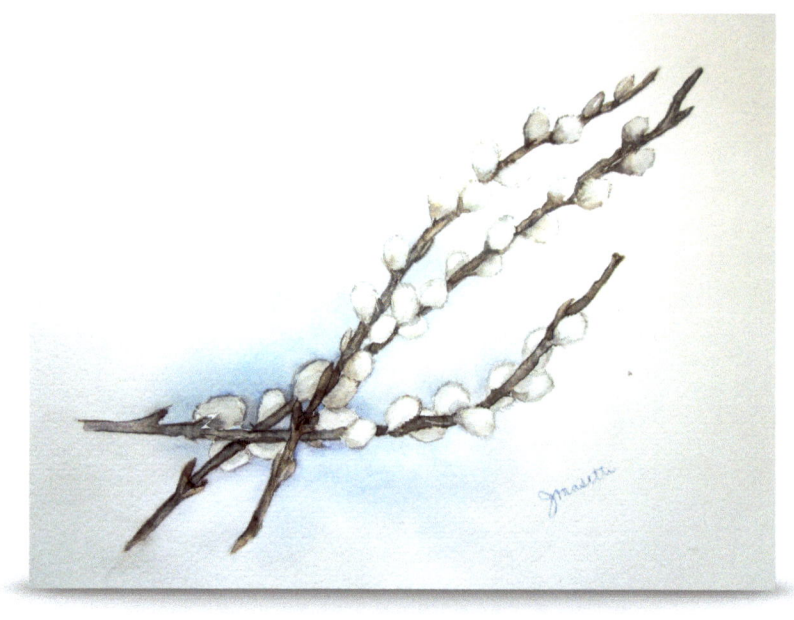

*It's a bright summer day and the ladies are all dressed in their chemise gowns to enjoy a summer tea.*

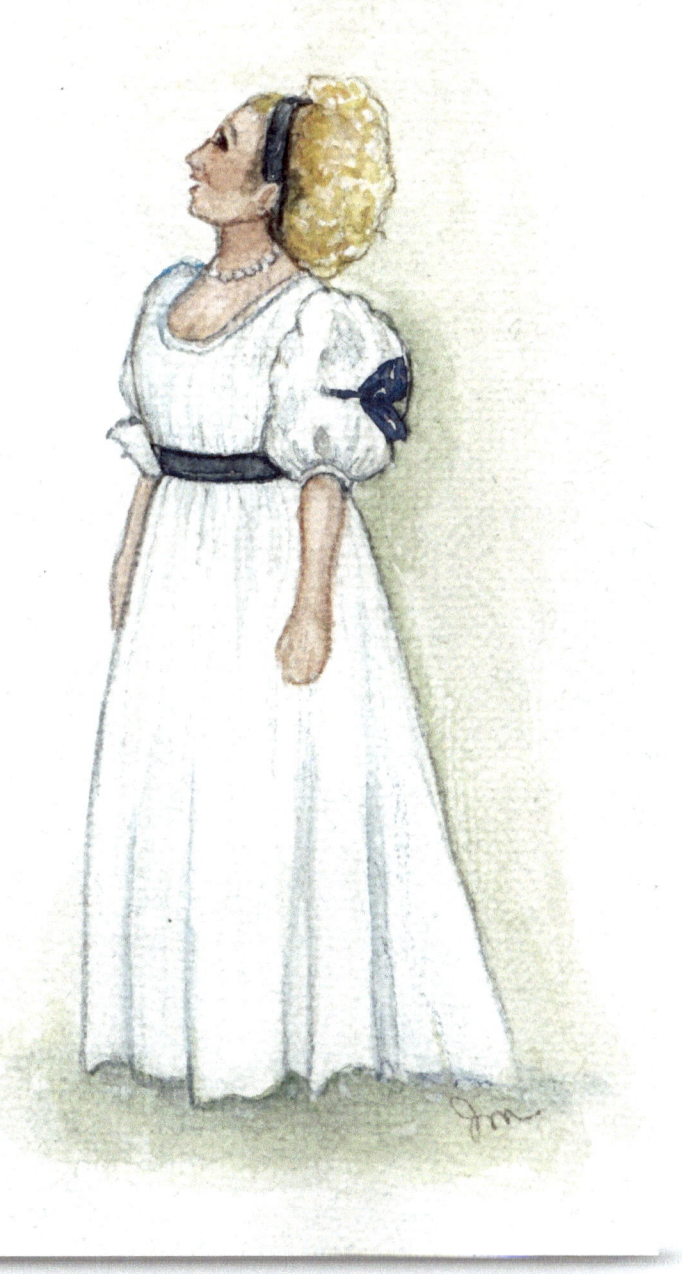

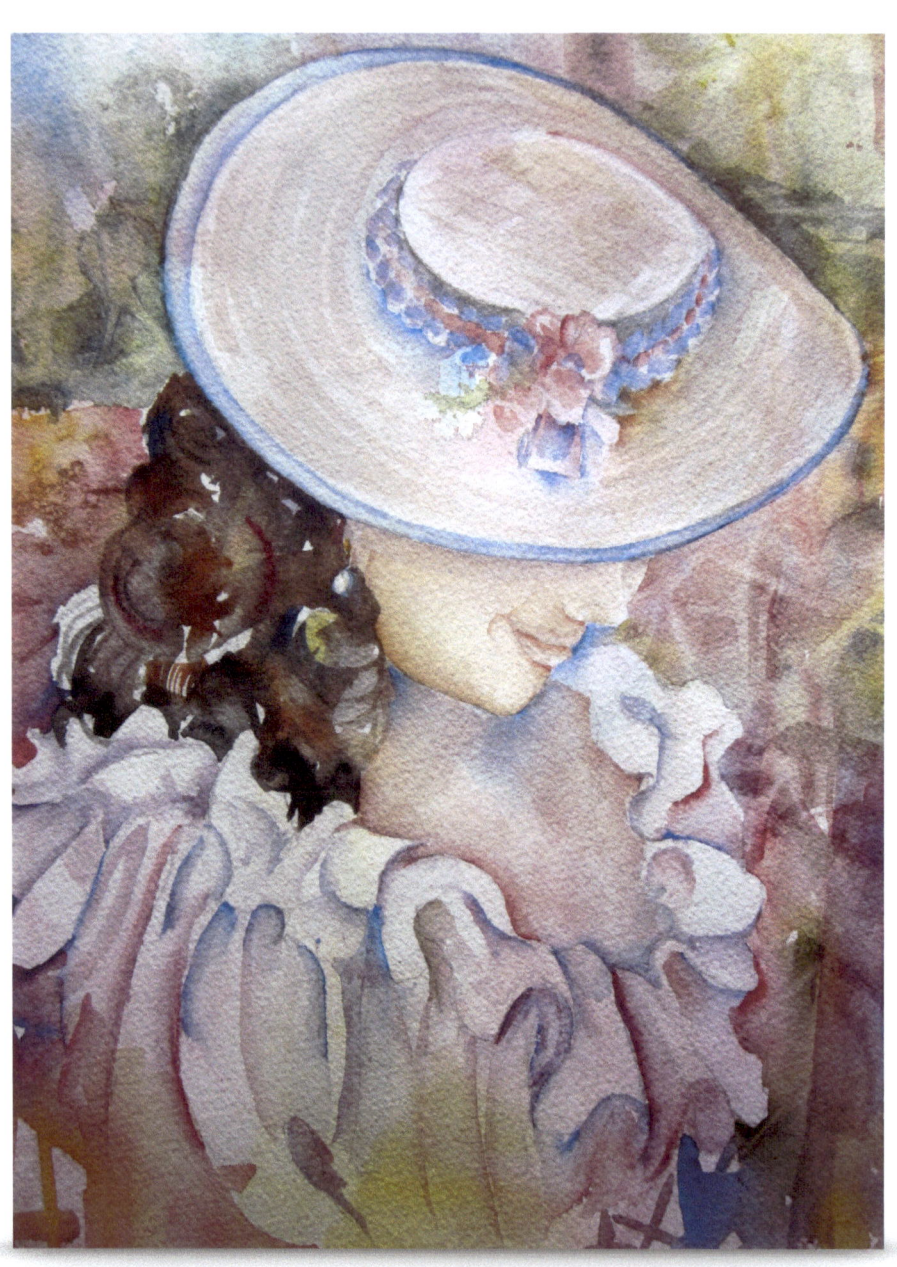

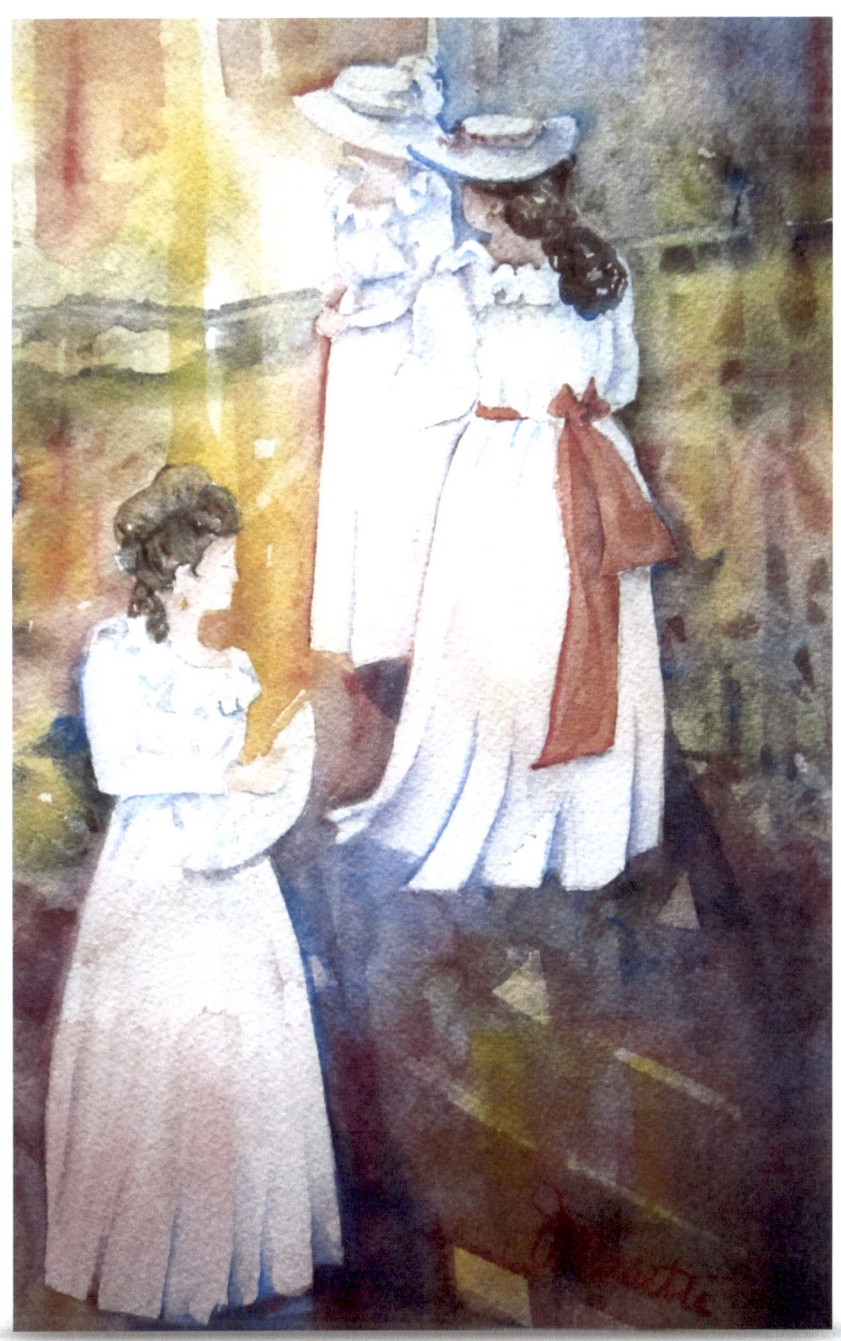

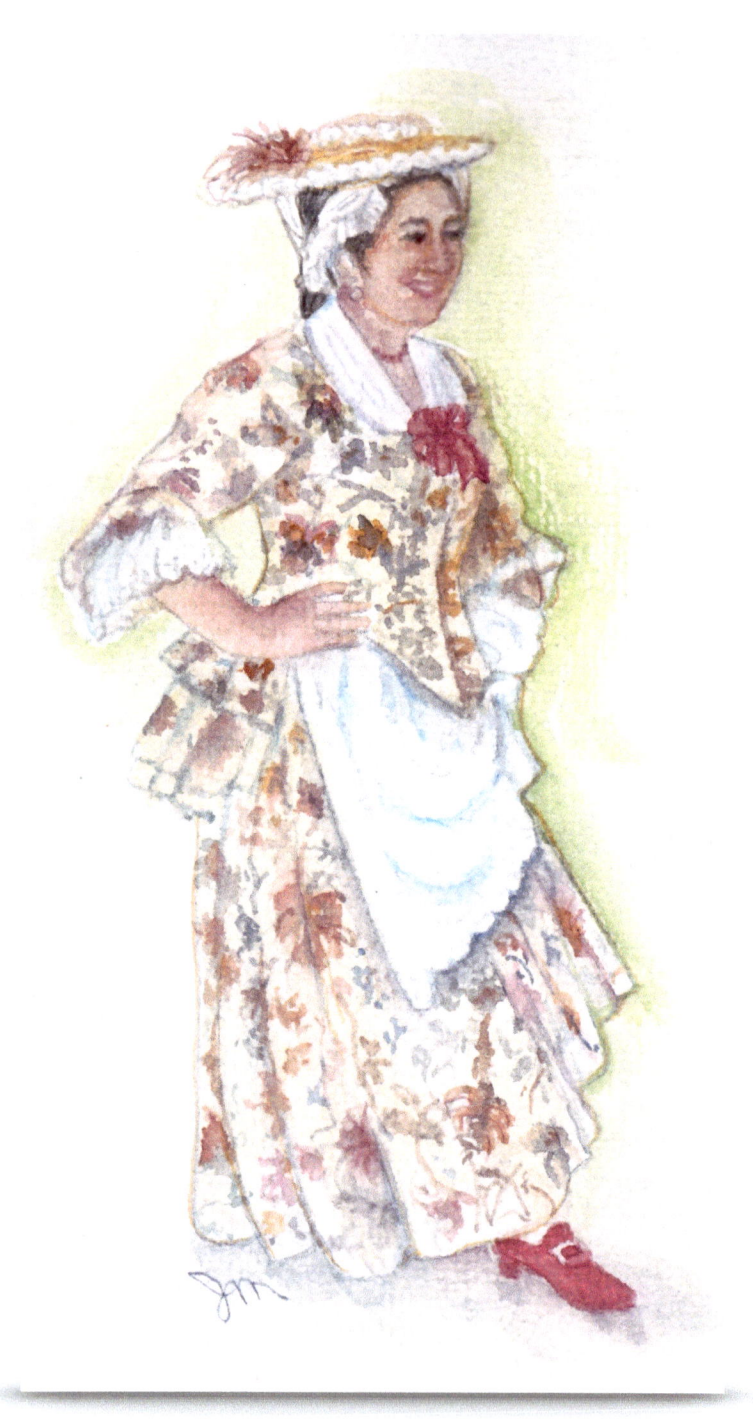

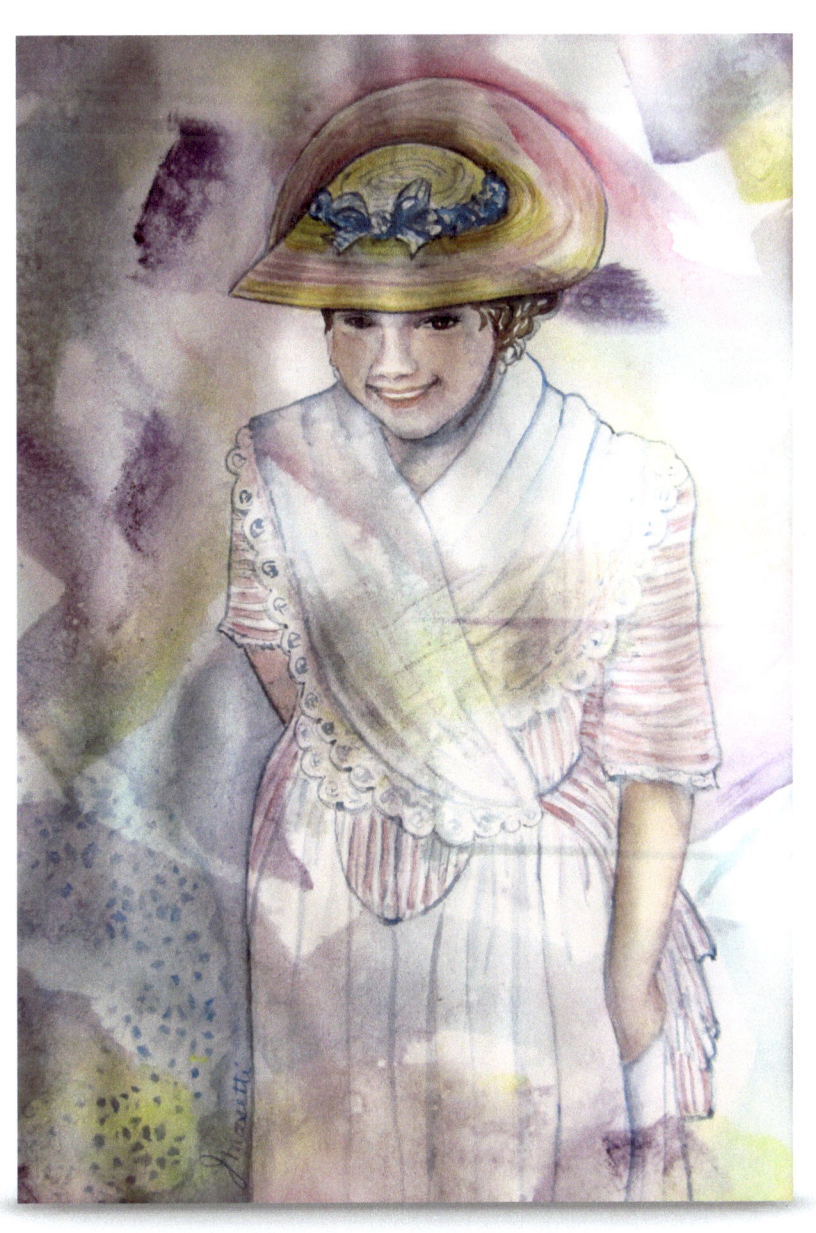

*To Market at Fort Fred*

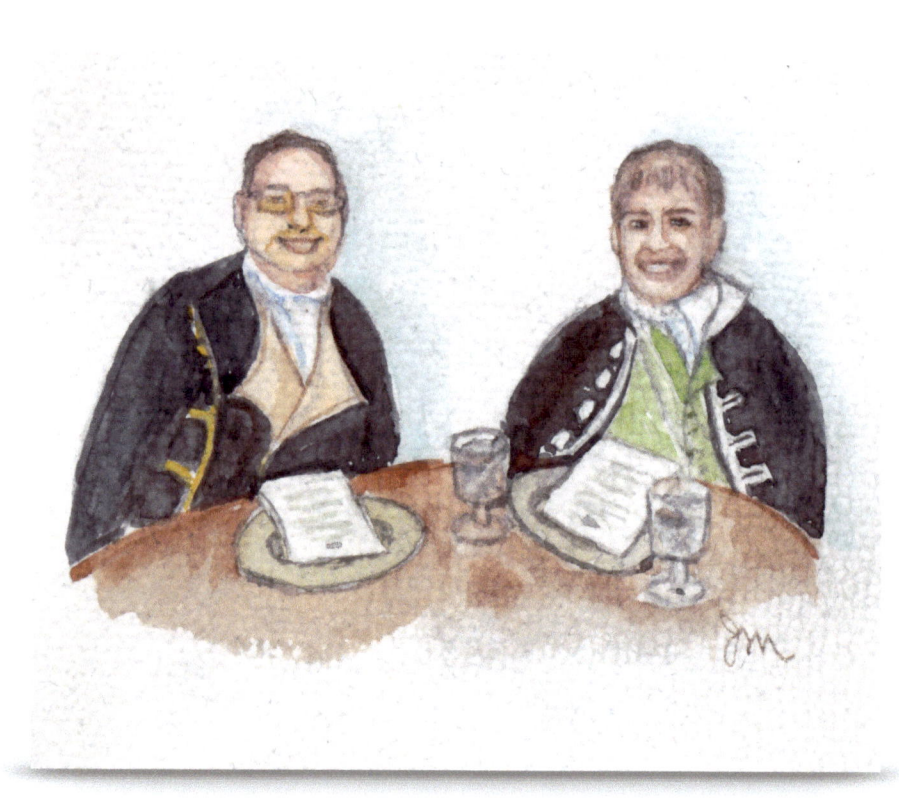

*Gentlemen at the Française Dinner and lovely ladies in their favorite gowns.*

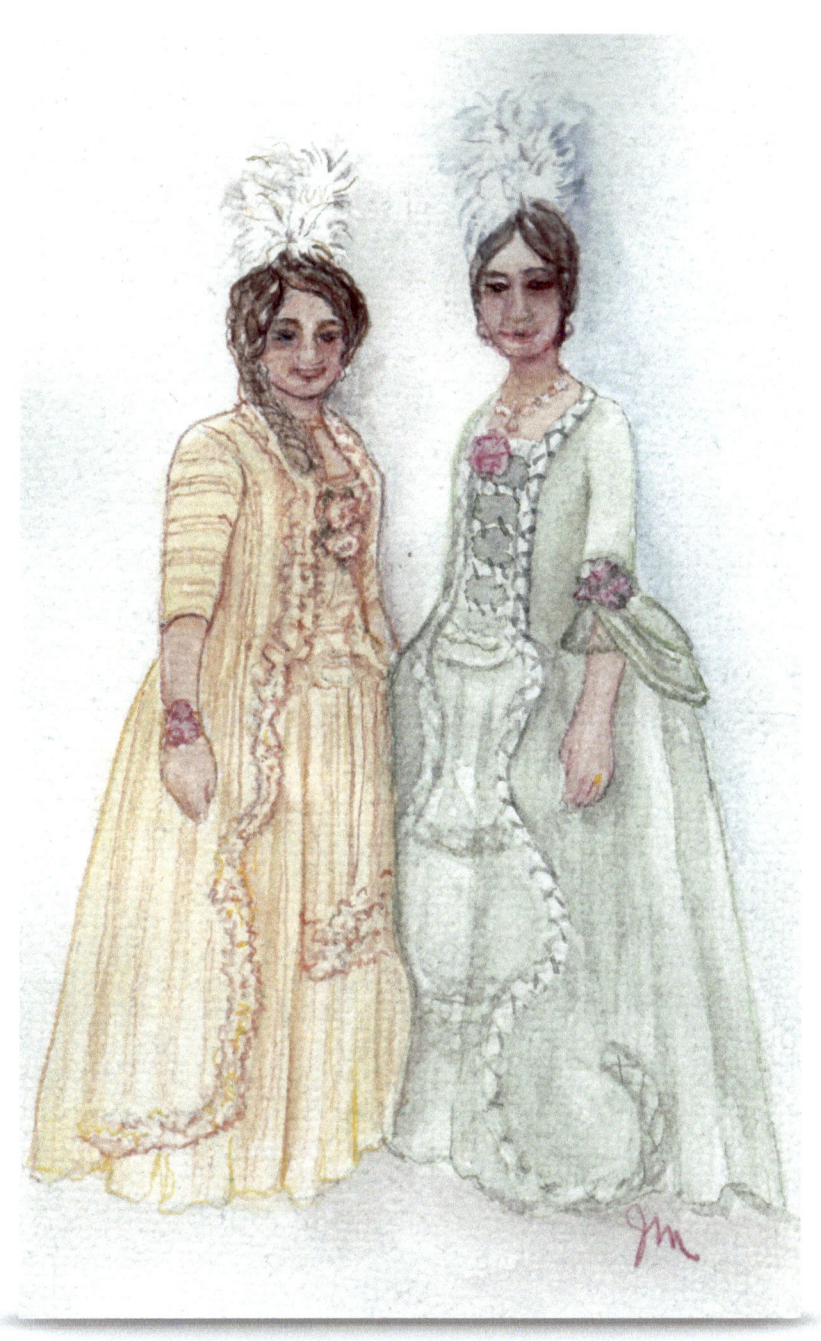

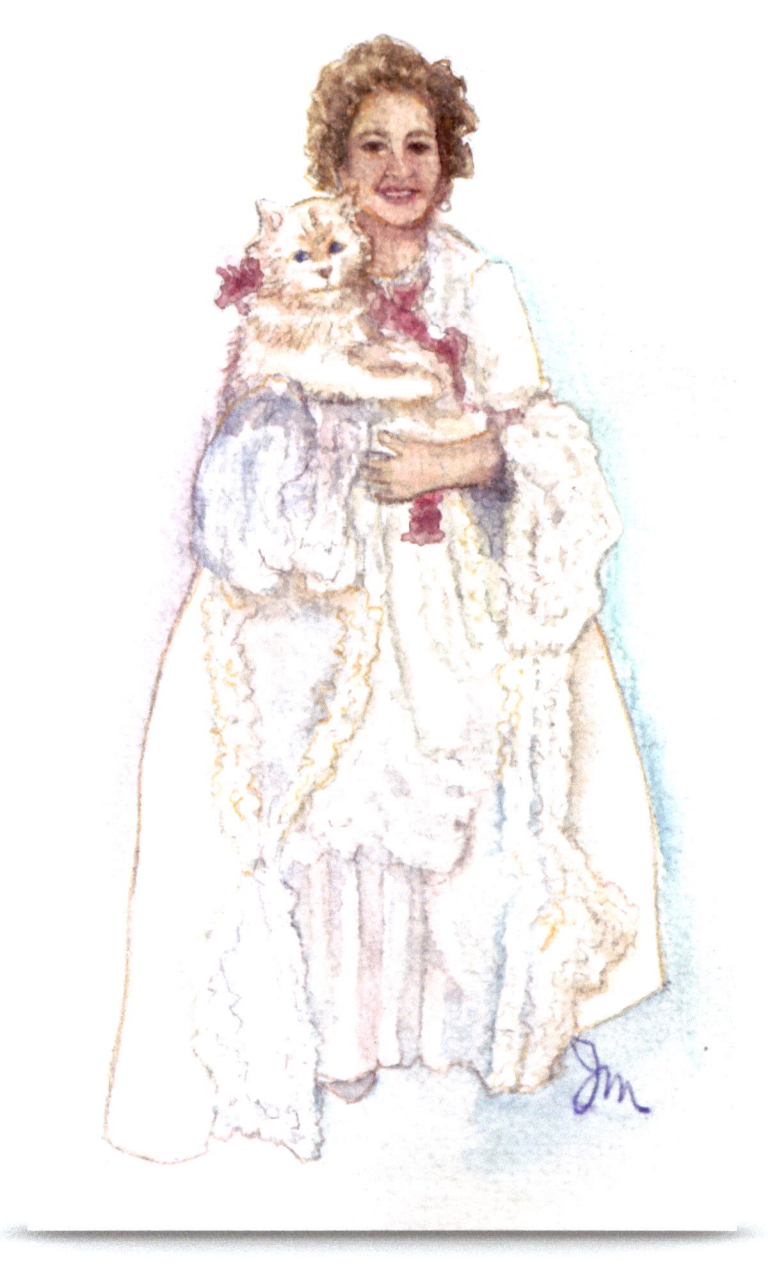

*Dressed in Princess Caroline Sacque and Pet Willow with Her Bow*

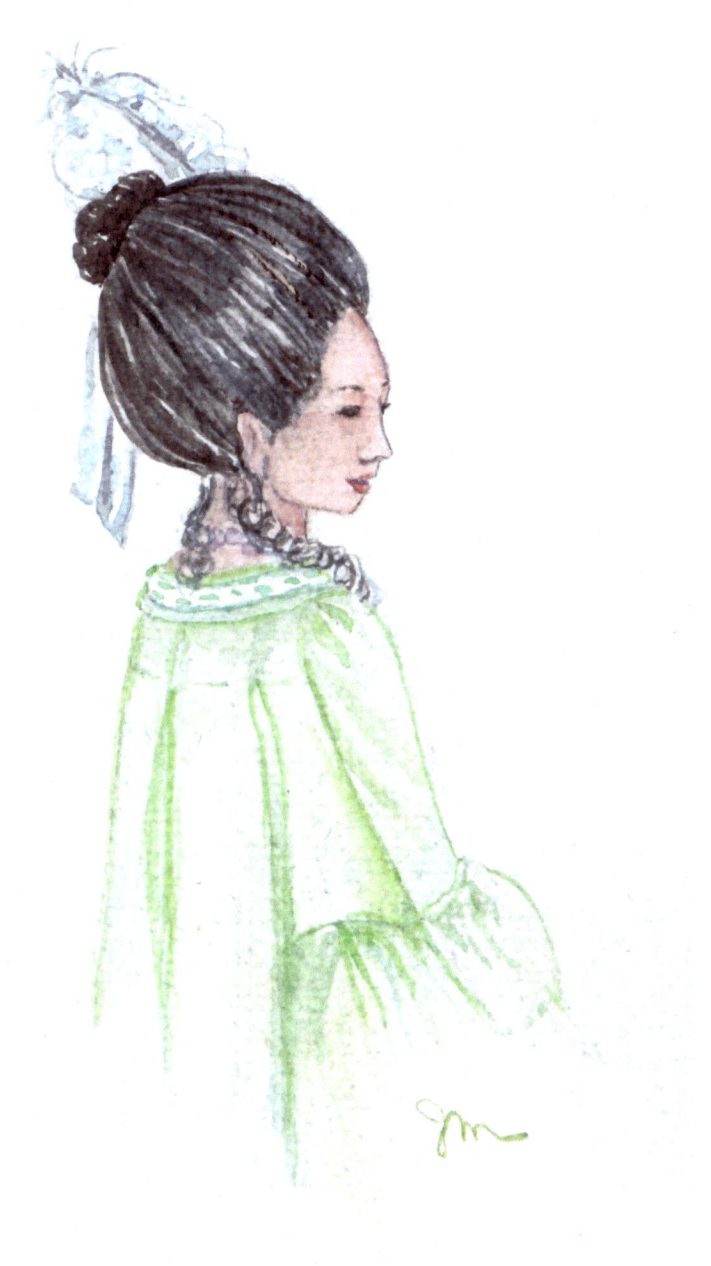

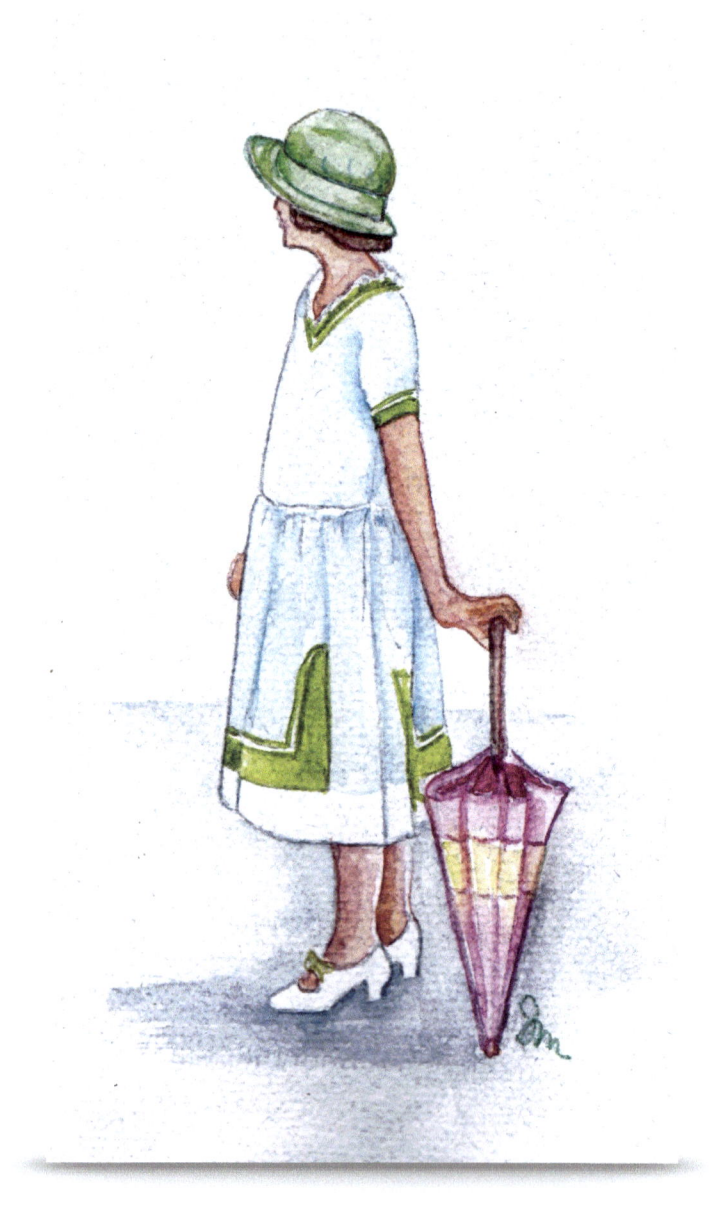

*The 1920's*

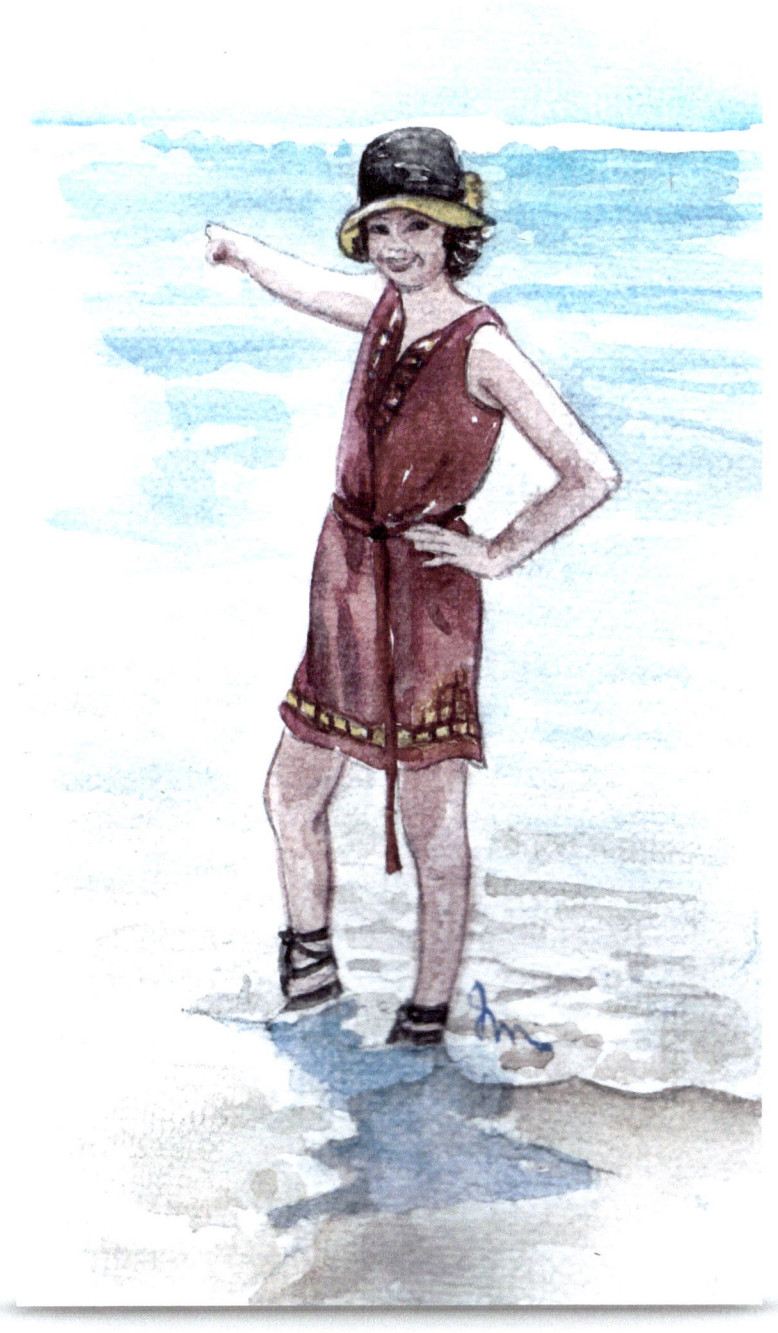

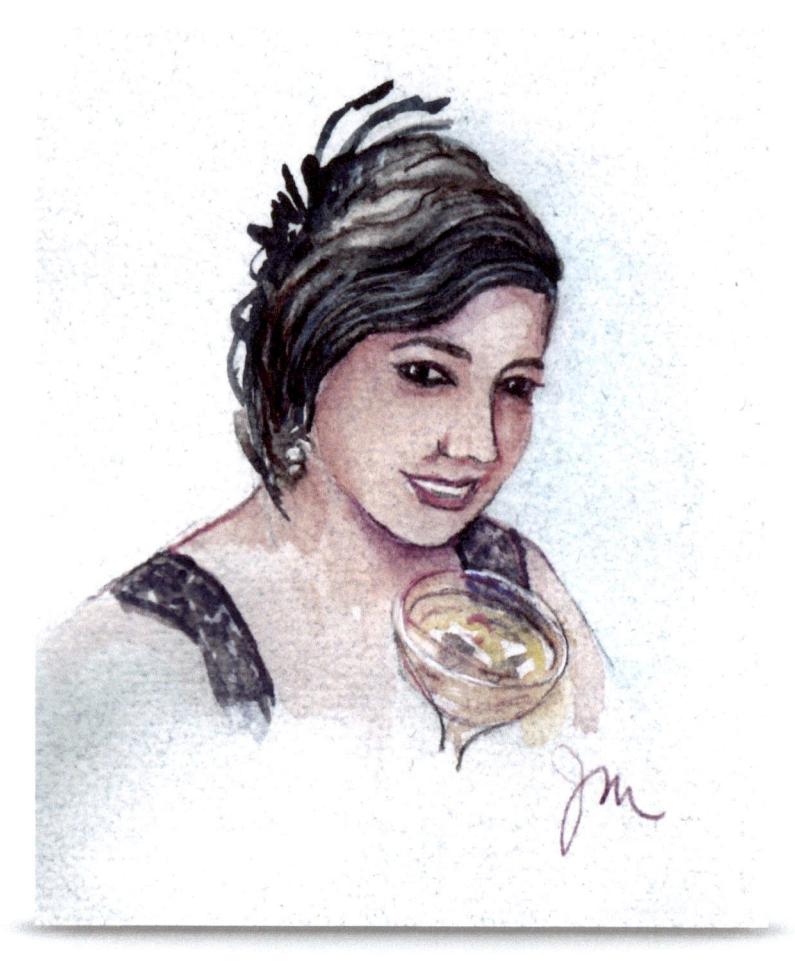

*Toast to the Town*

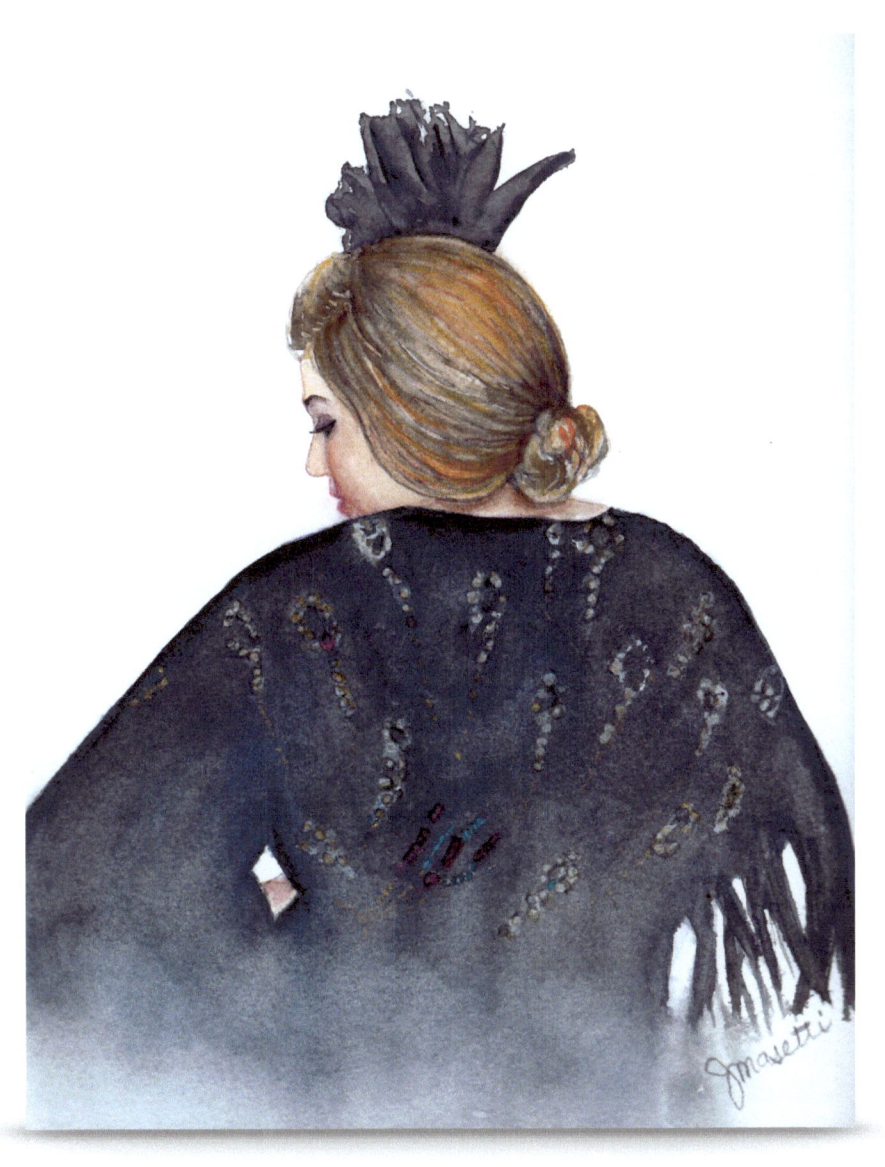

A Gatsby-era event called the
Eight-Thirteen ball

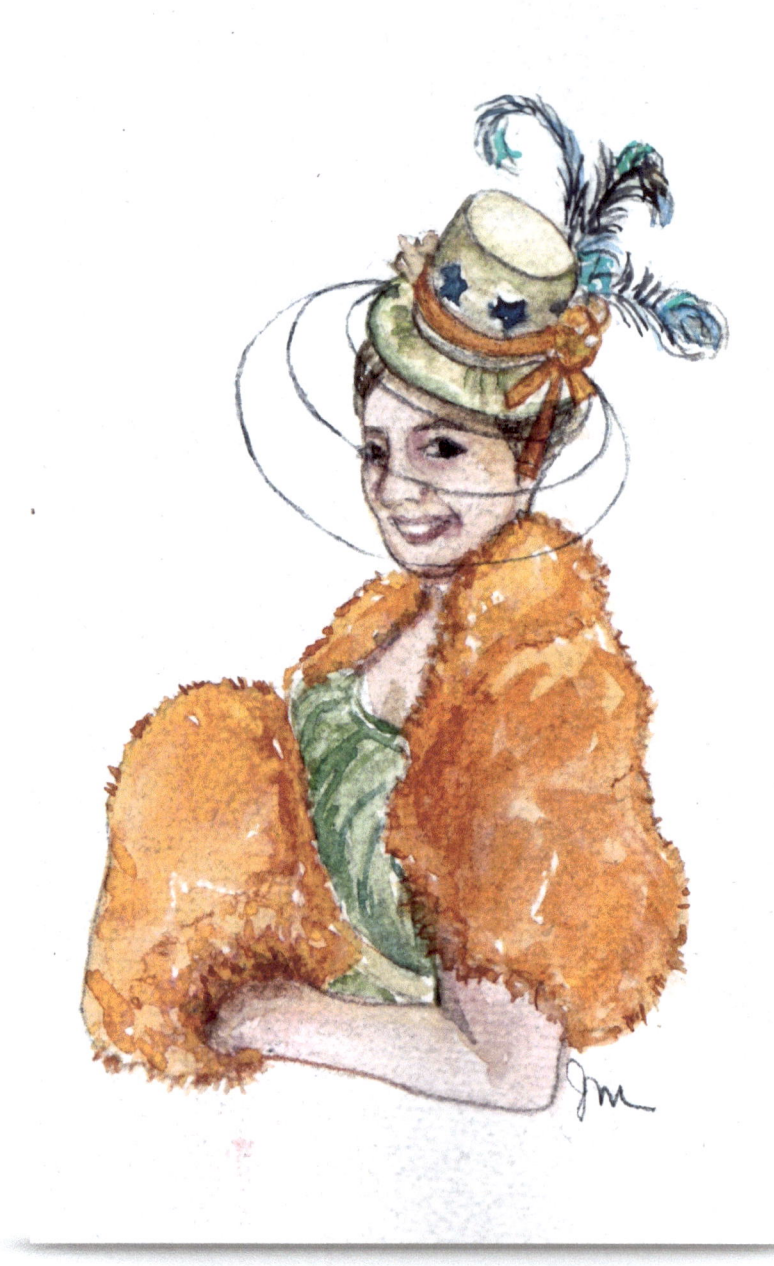

Mad Hatter Party

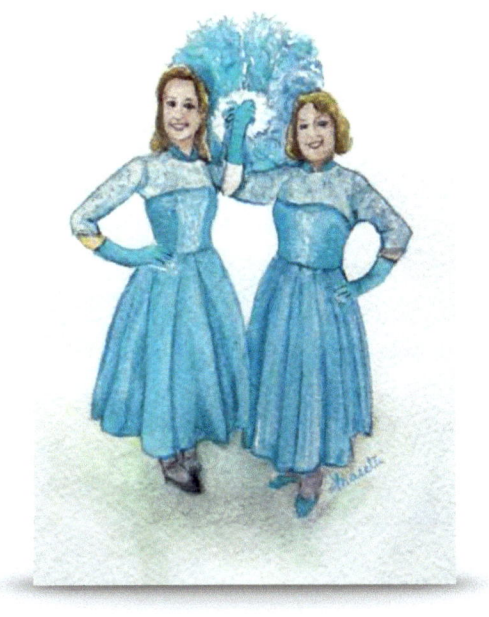

*There is no doubt that the cinema has had a strong impact on period costume making. We might remember the sister act in the movie "White Christmas."*

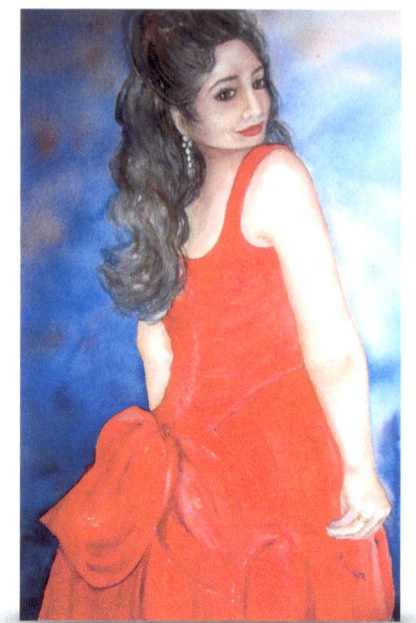

*Moulin Rouge Gown*

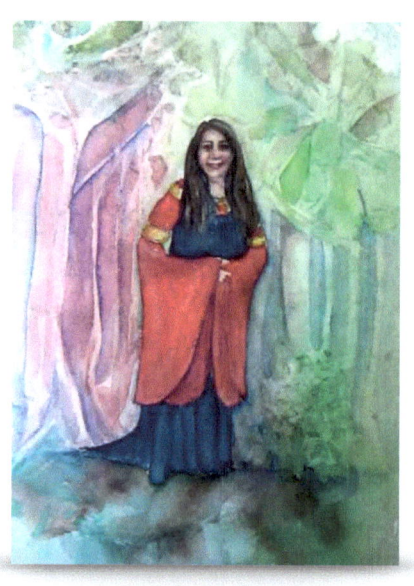

*Arwen Gown*

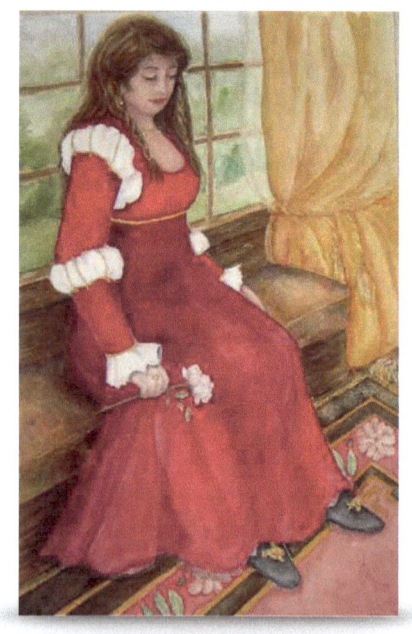

*Ever After Gown*

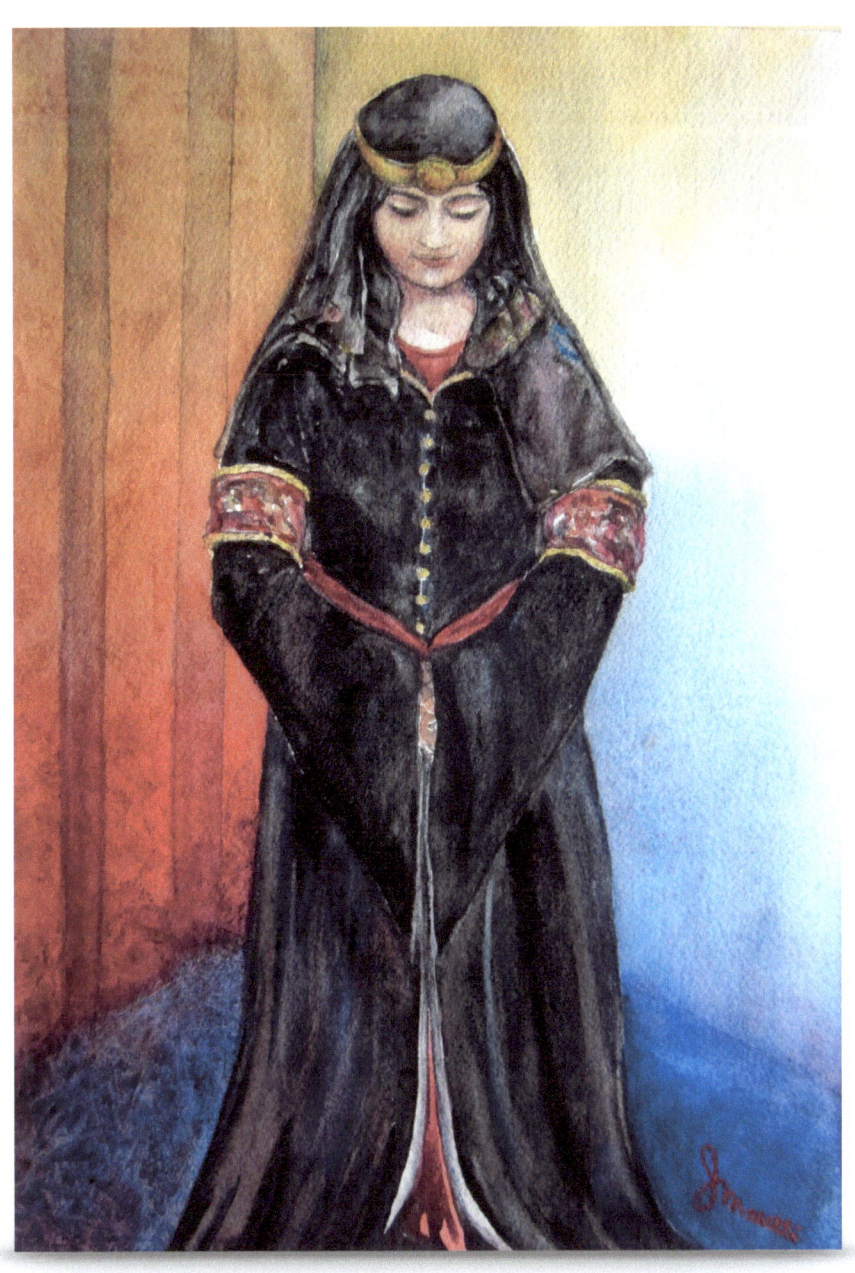

*Lord of the Rings Mourning Dress*

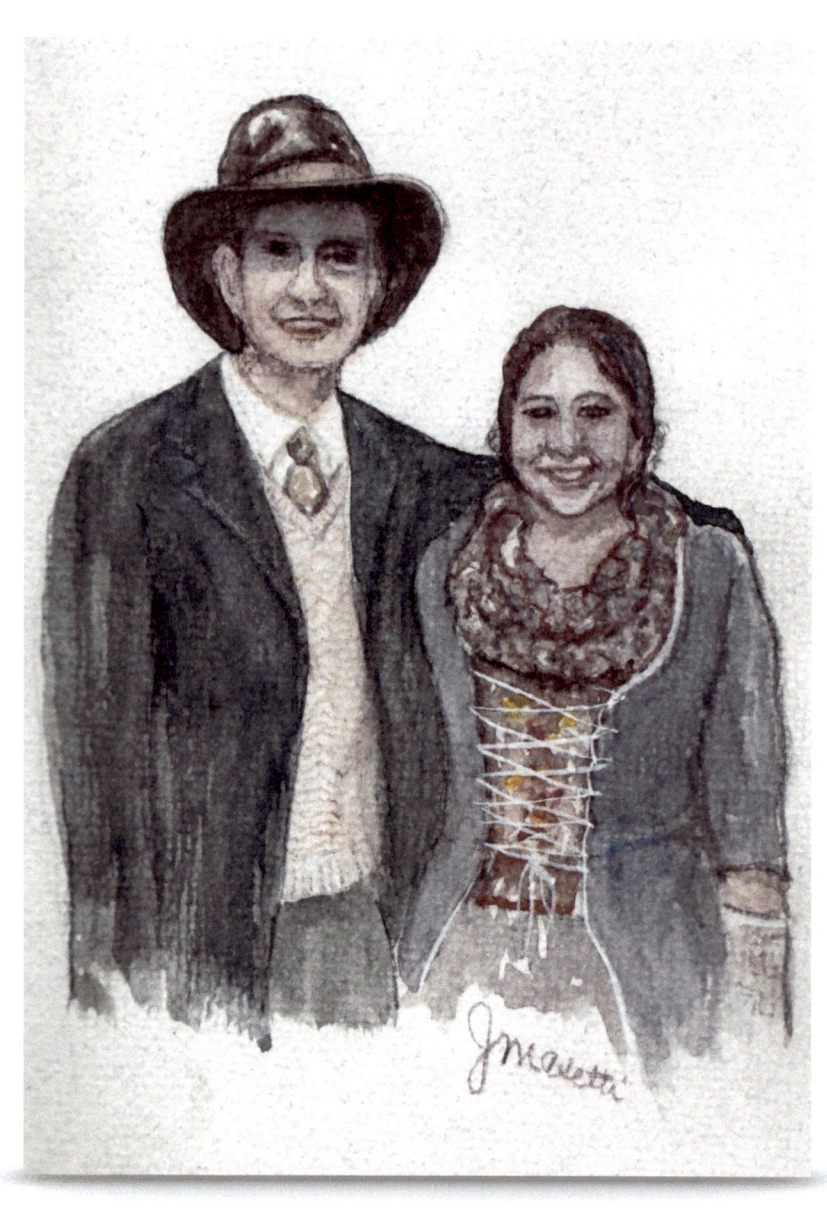

Outlander

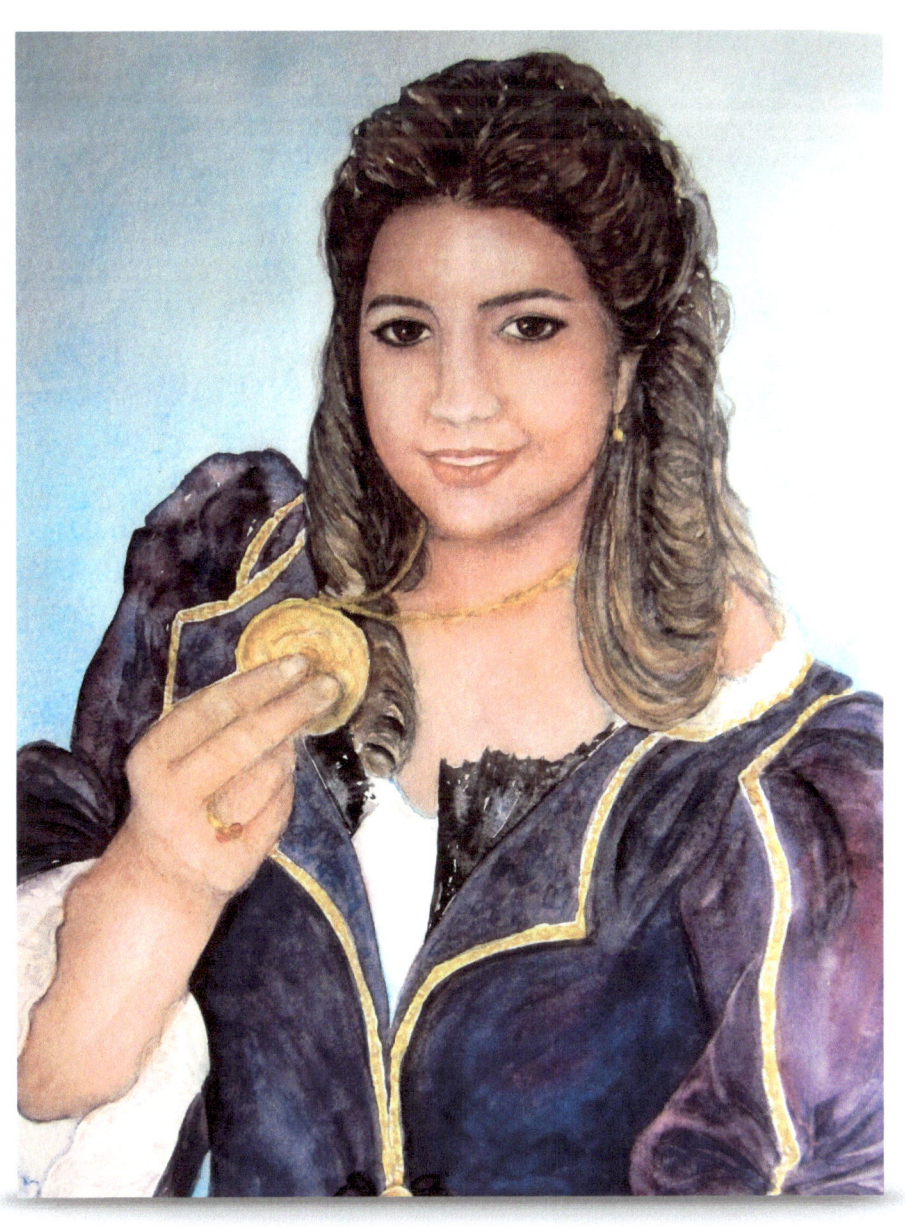

*Pirates of the Caribbean*

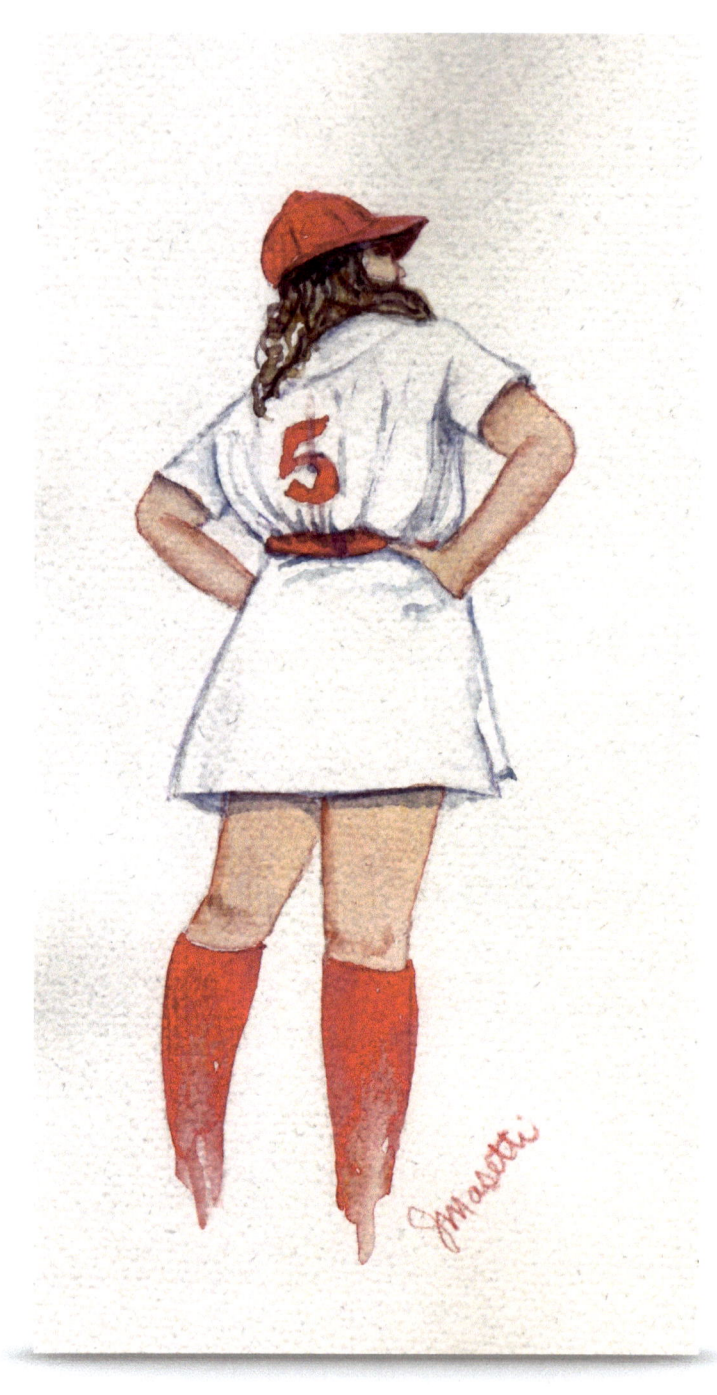

*A League of Their Own*

My brush and I will continue our journey of painting our little watercolor sketches. Til our next book...farewell.

*My website is jeanmasetti.com*

*My Blog is art2love.livejournal.com*

*My Facebook Page is "Watercolor with Jean"*

www.ingramcontent.com/pod-product-compliance
Lightning Source LLC
Chambersburg PA
CBHW041113180526
45172CB00001B/230